Art Therapy
Mandalas

100
DESIGNS
COLOURING IN AND MEDITATION

illustrated by Sophie Leblanc

jacqui
small

First published in the UK, USA and Australia in 2014 by
Jacqui Small LLP
74–77 White Lion Street
London N1 9PF

Text © 2014 Jacqui Small LLP

First published by Hachette Livre (Hachette Pratique), 2013
© Hachette Livre (Hachette Pratique), 2013

Illustrations: Sophie Leblanc
Translation: Hilary Mandleberg

ISBN: 978 1 909342 76 7

10 9 8 7 6 5 4 3

Printed in China

The Whole Universe in a Single Circle

The mandala is universal. Circular forms that bring together a variety of other geometric shapes are found in many different cultures. However, the Sanskrit word *mandala* is linked with Tantric Buddhism (Vajrayana) and its practice. The circle and its centre, in its purest sense, represent the entire universe. They remind us of our relationship with the world.

In Tibet, a mandala is made of coloured sand: it is no sooner finished than, making their offering to the divine, the monks blow it away with a single puff of breath. This practice reminds us that everything in this world is ephemeral; there is no point becoming attached to material things.

In everyday life and for each and every one of us, a mandala can be a means of meditation and visualization. You can use the colours that Buddhism traditionally associates with nature's elements – white, yellow, green, blue, red – or you can allow your imagination free rein.

Colouring in a mandala forces you to concentrate and breathe harmoniously. It also stems the flow of thoughts that assail our brains.

The 100 mandalas in this book are inspired by Tibetan and Hindu traditions, but they also offer you the chance to produce something original and spontaneous.

The path is different for everyone; the methods of achieving the goal vary with every traveller.
Tibetan proverb

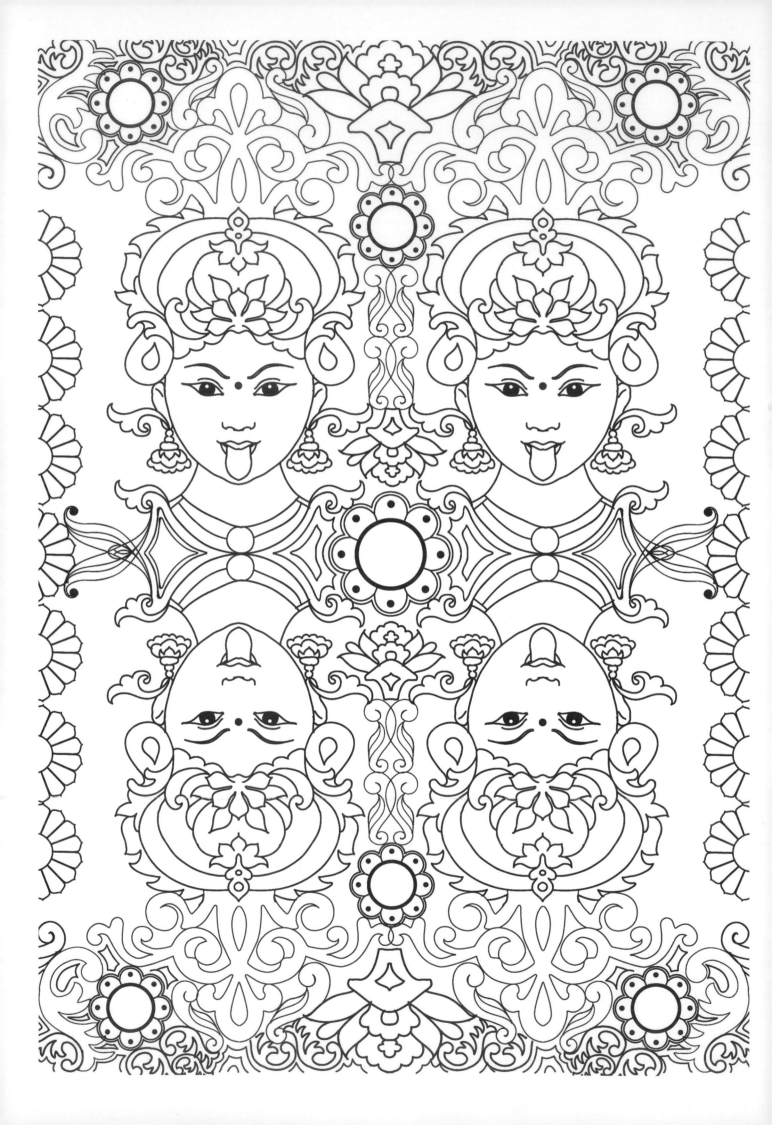

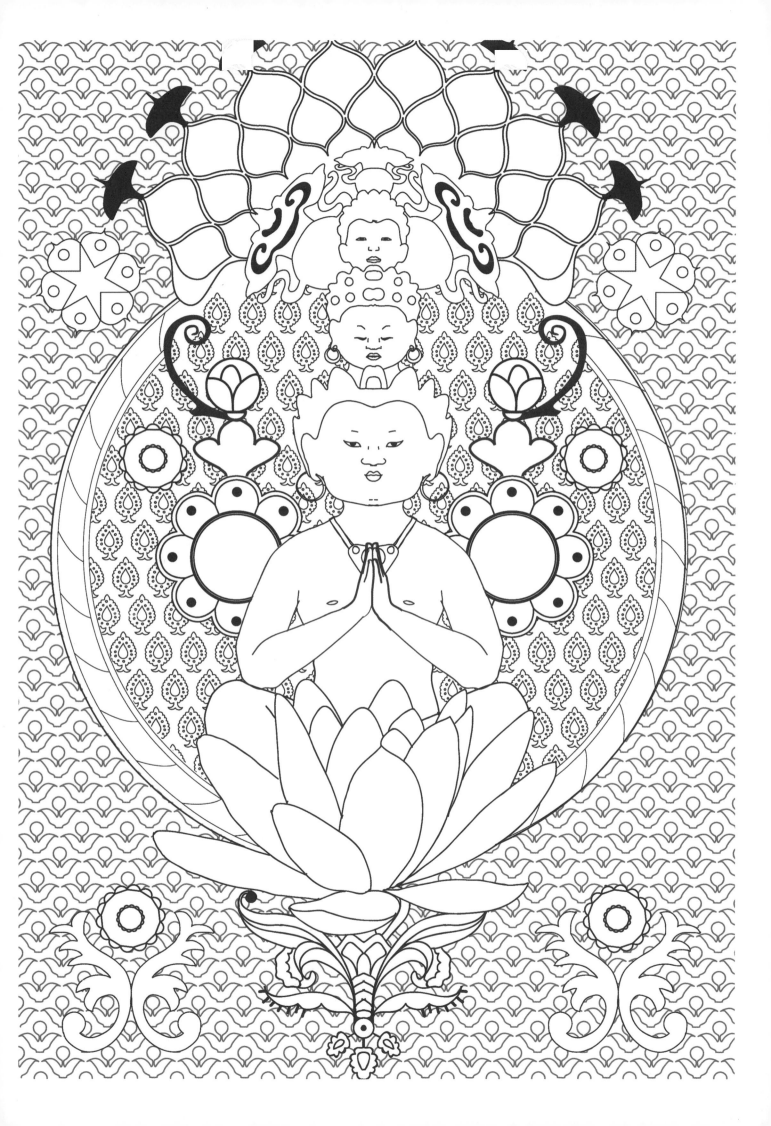

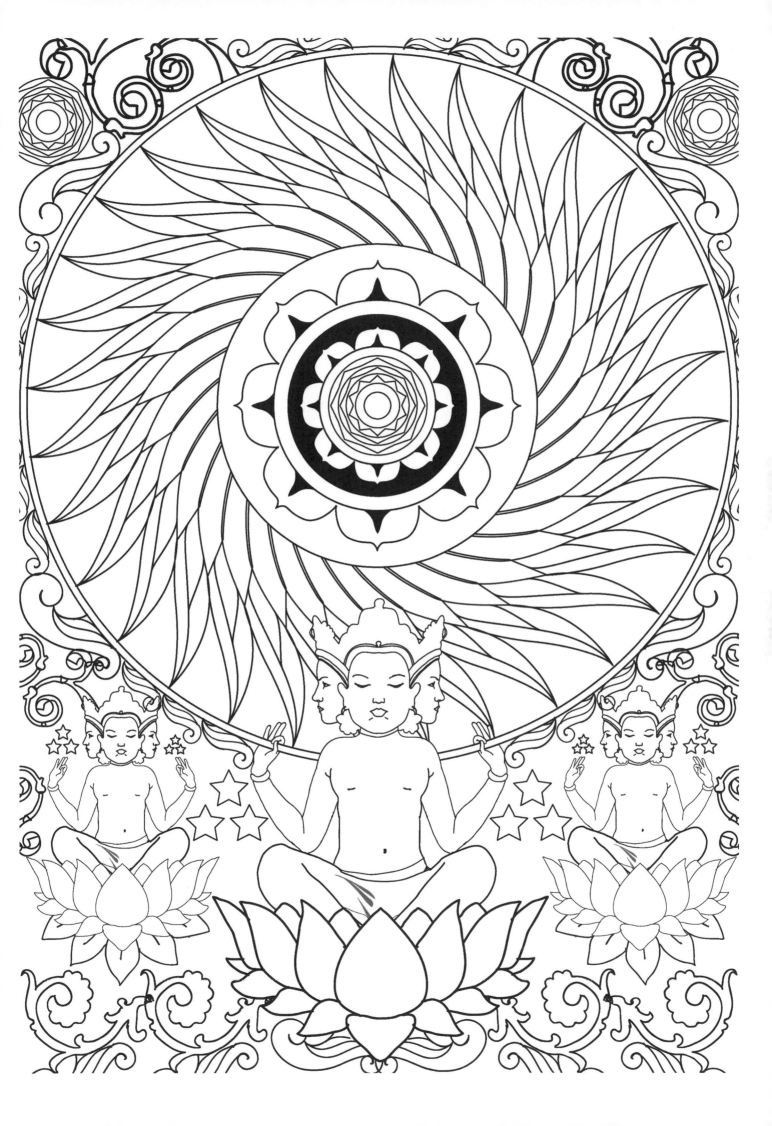

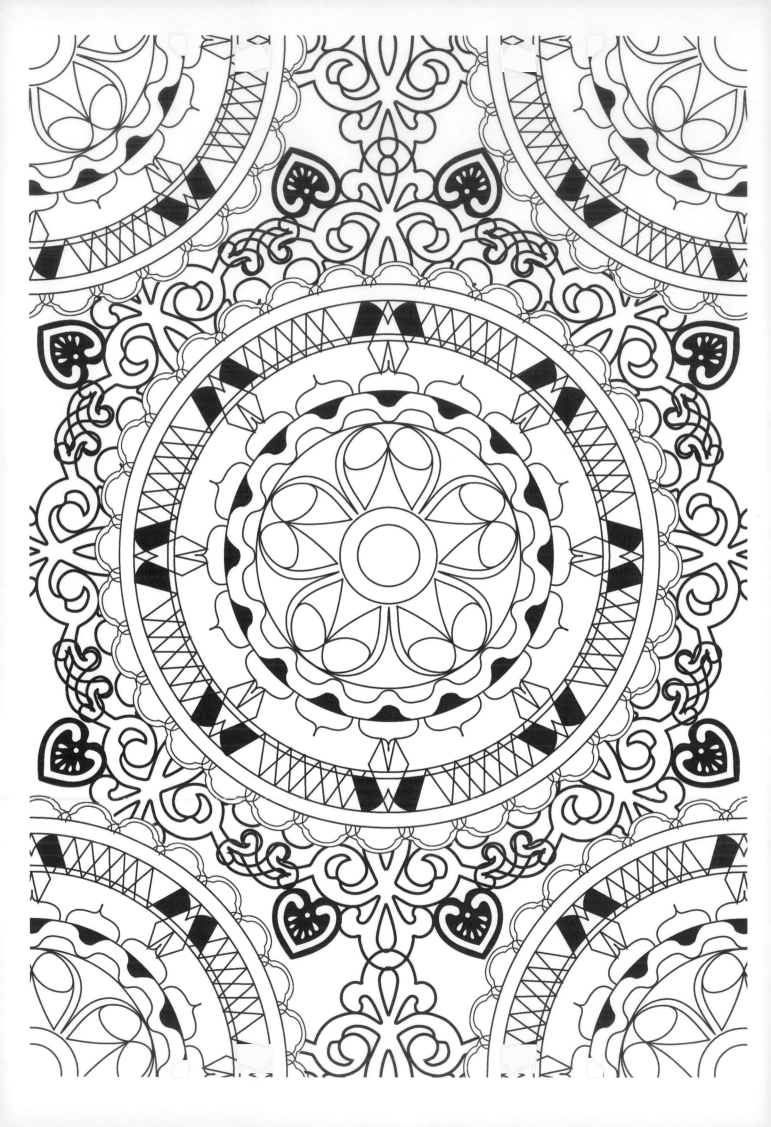

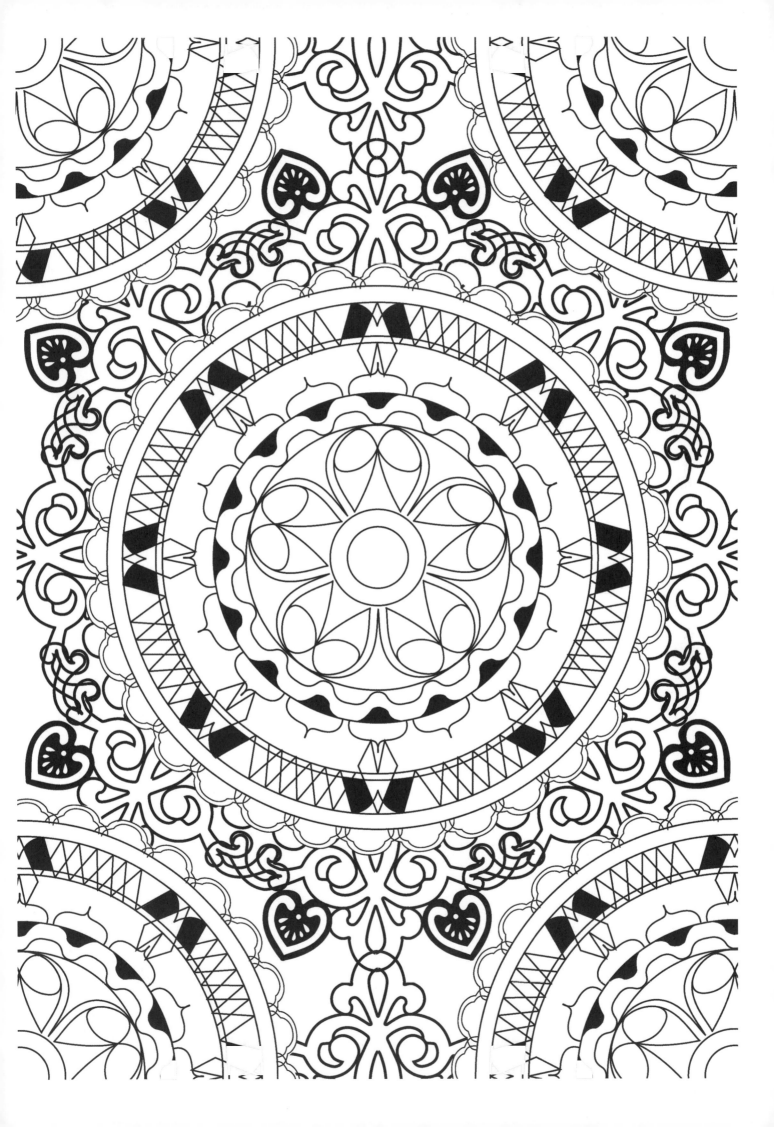

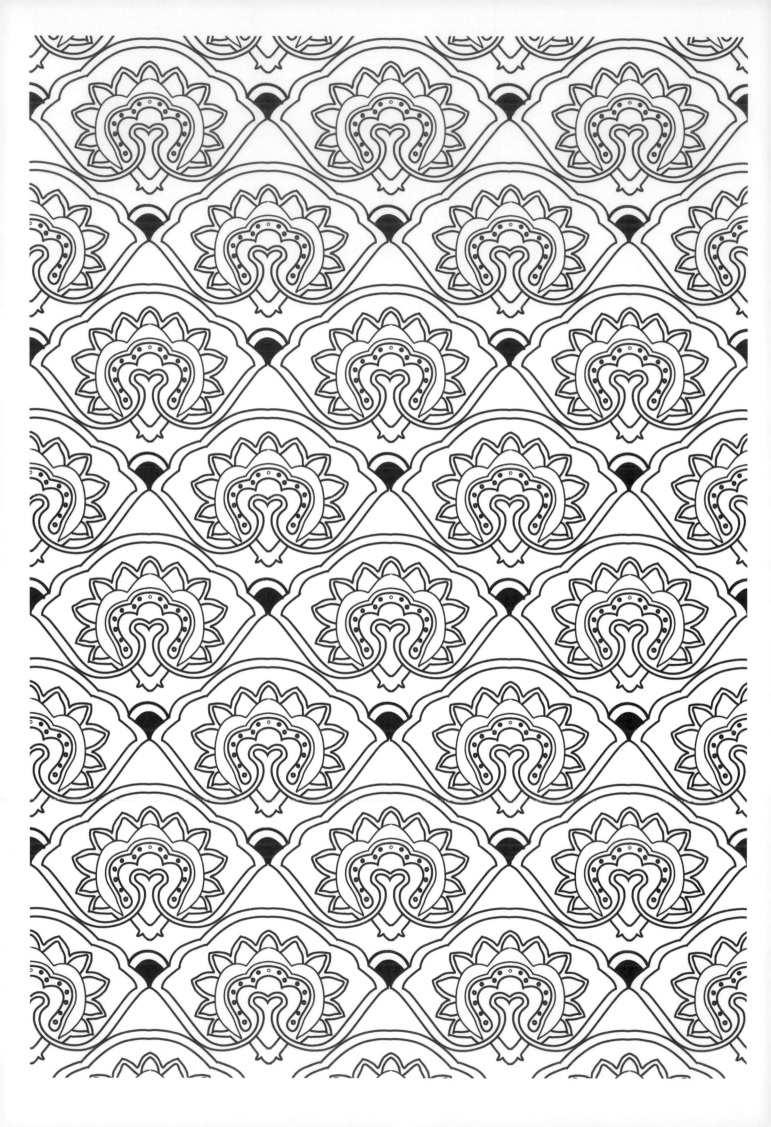

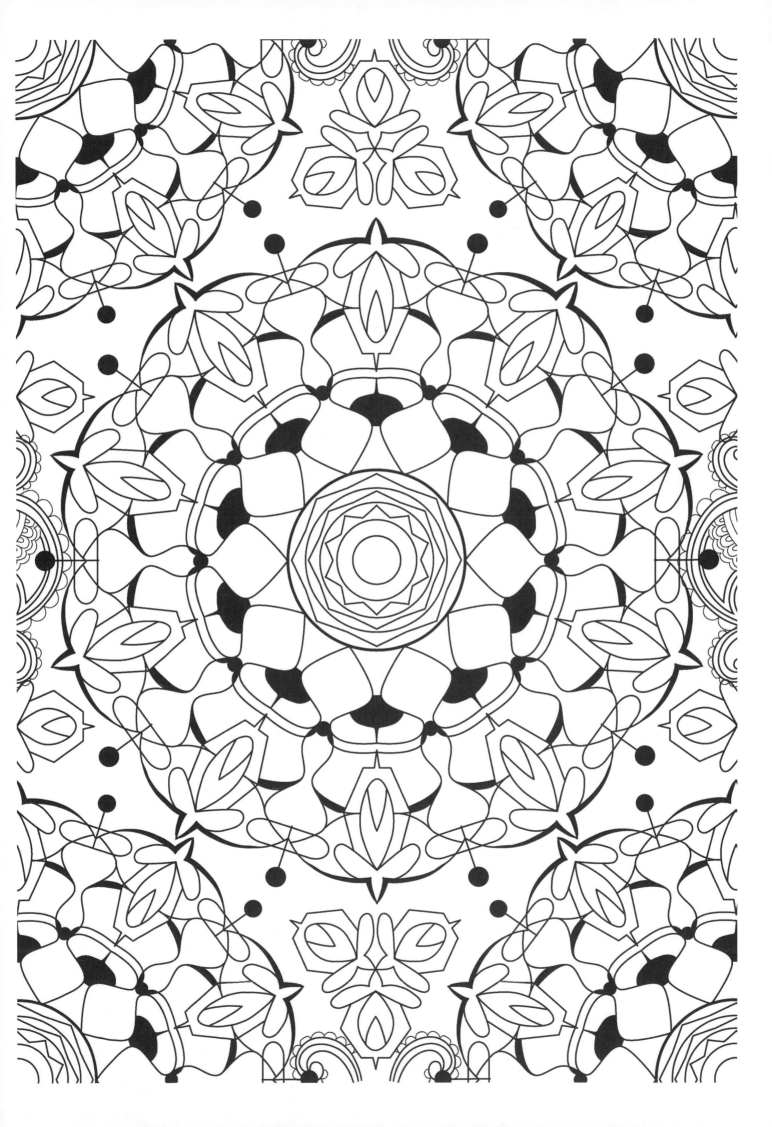

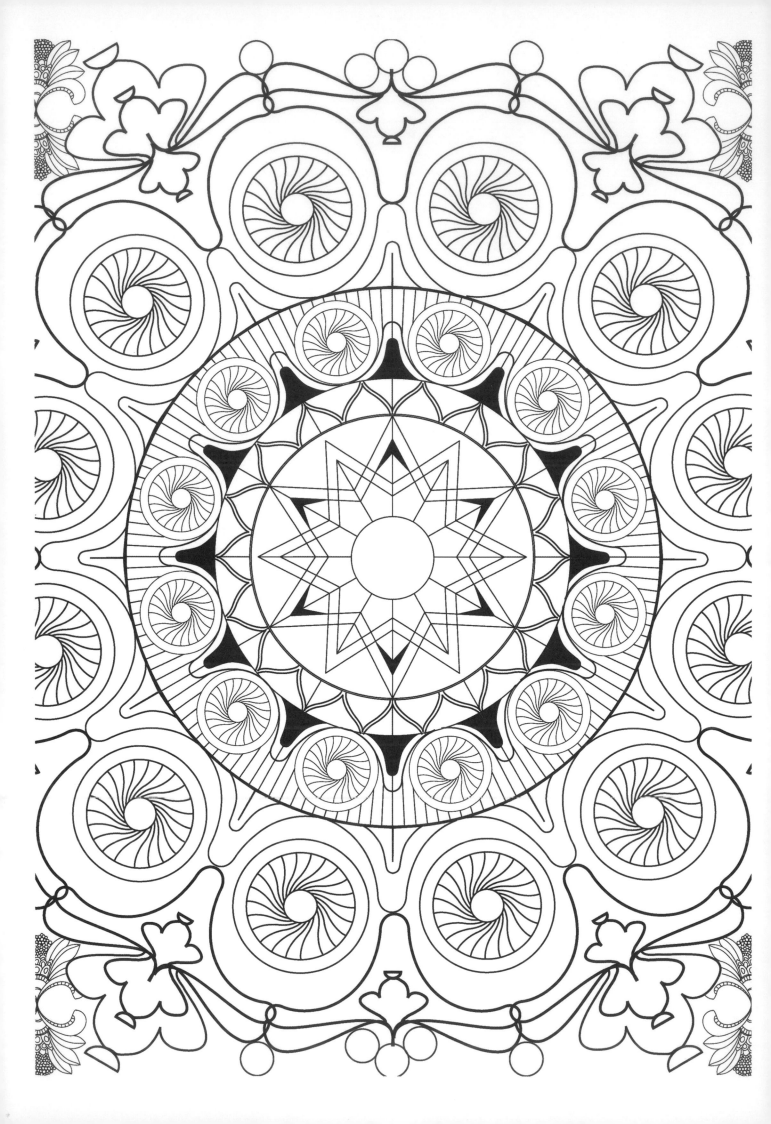

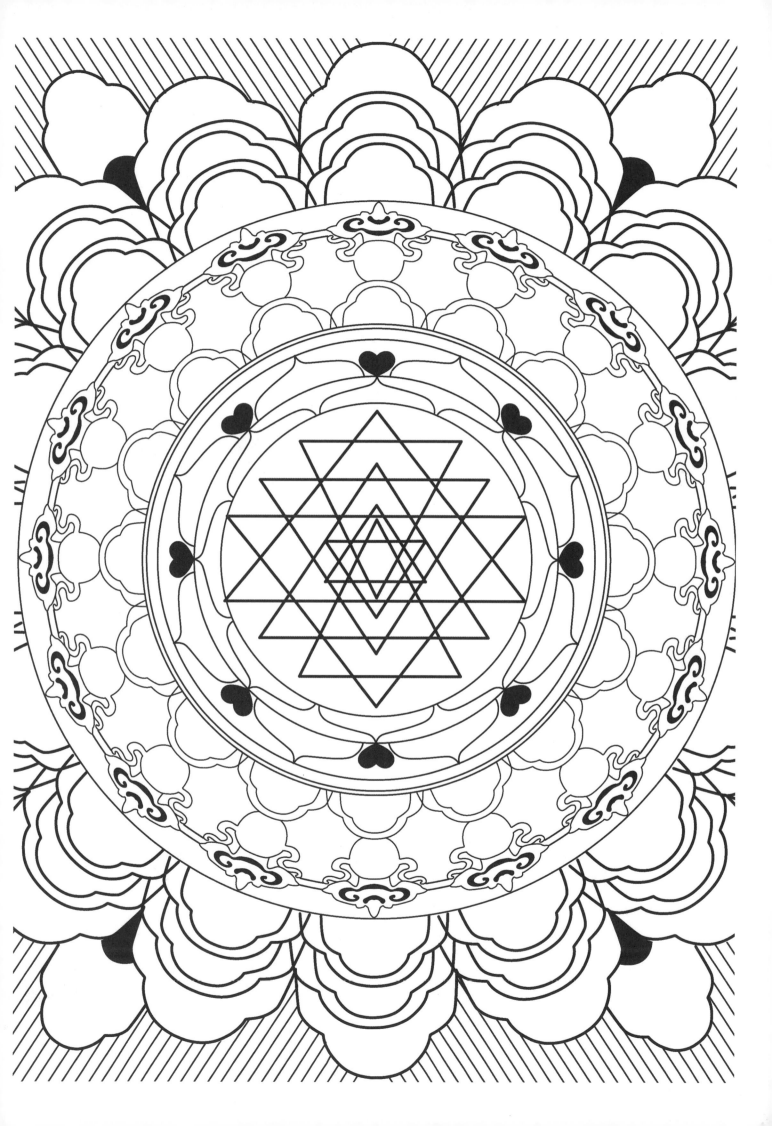

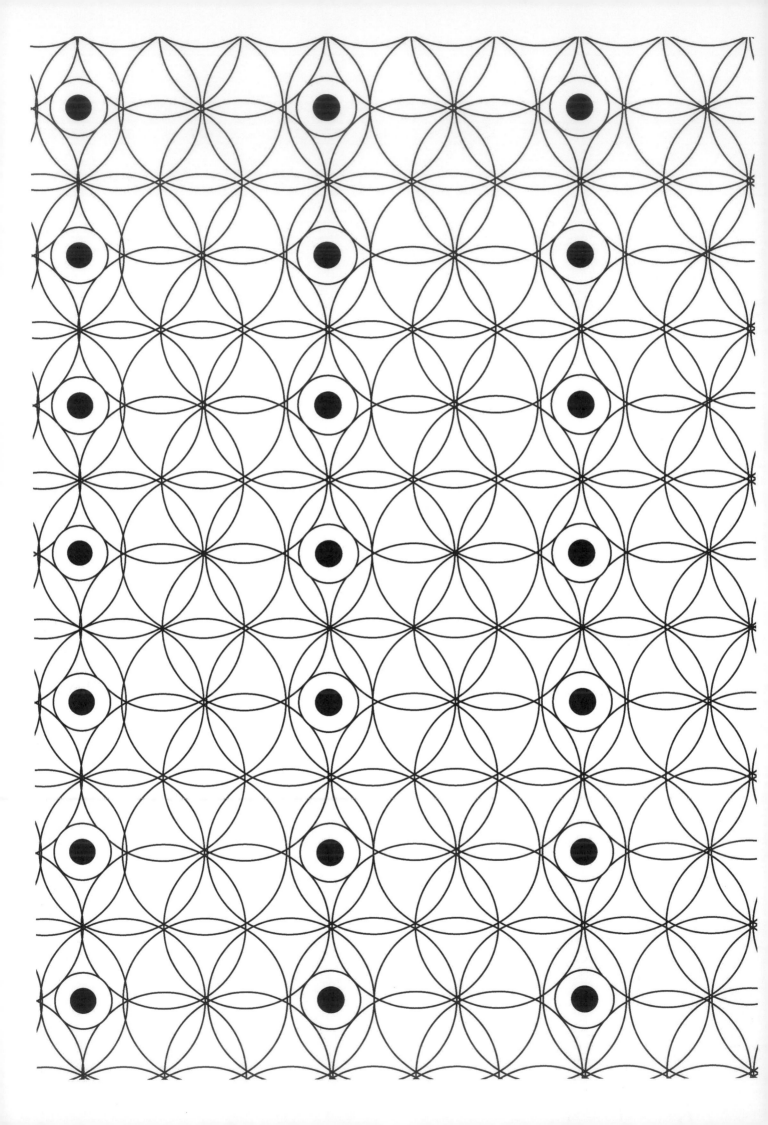

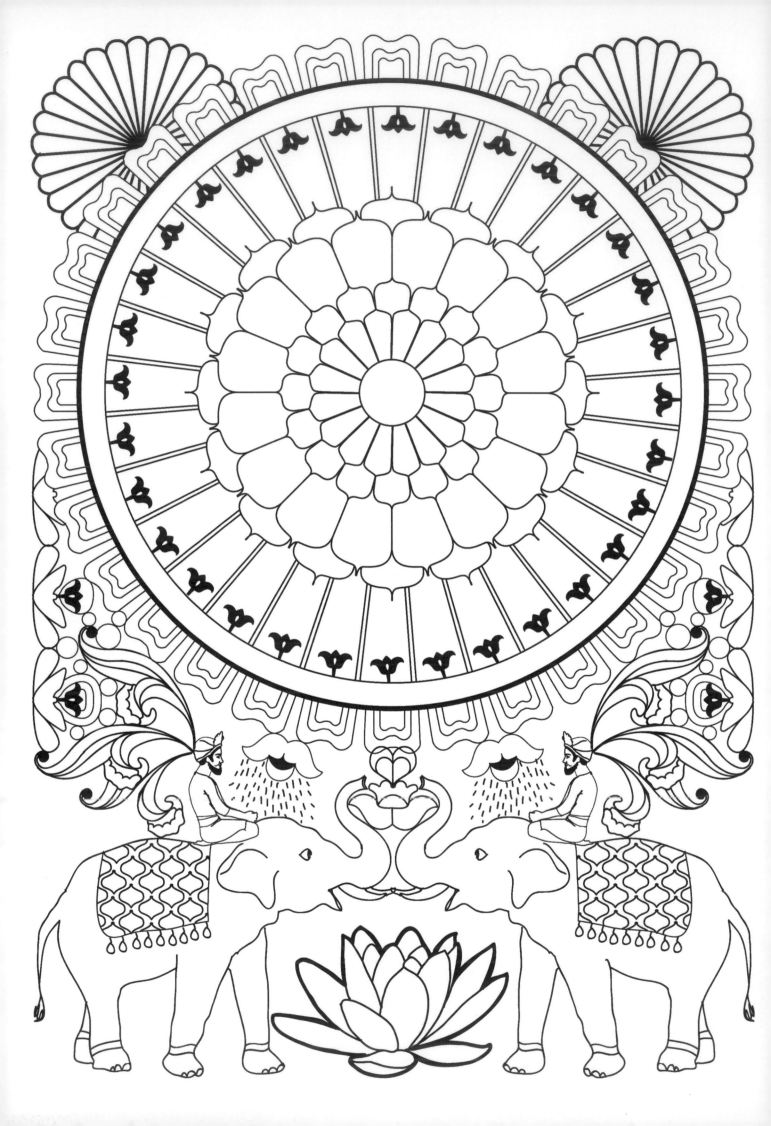

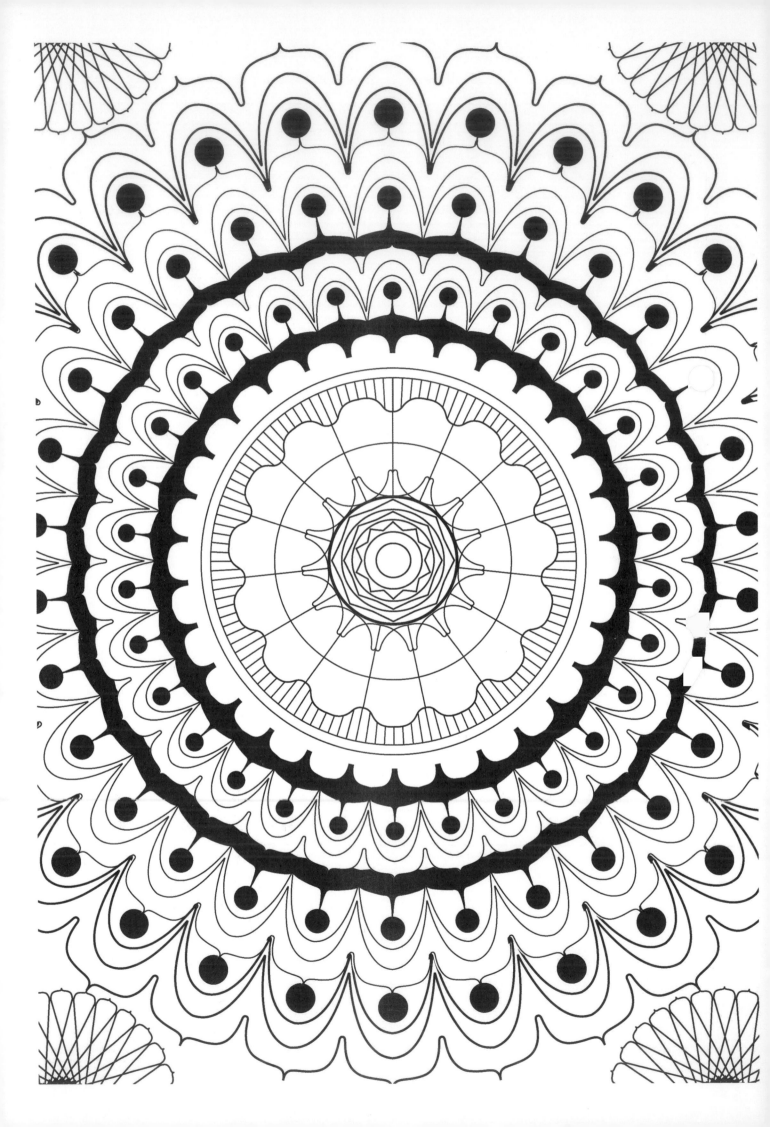

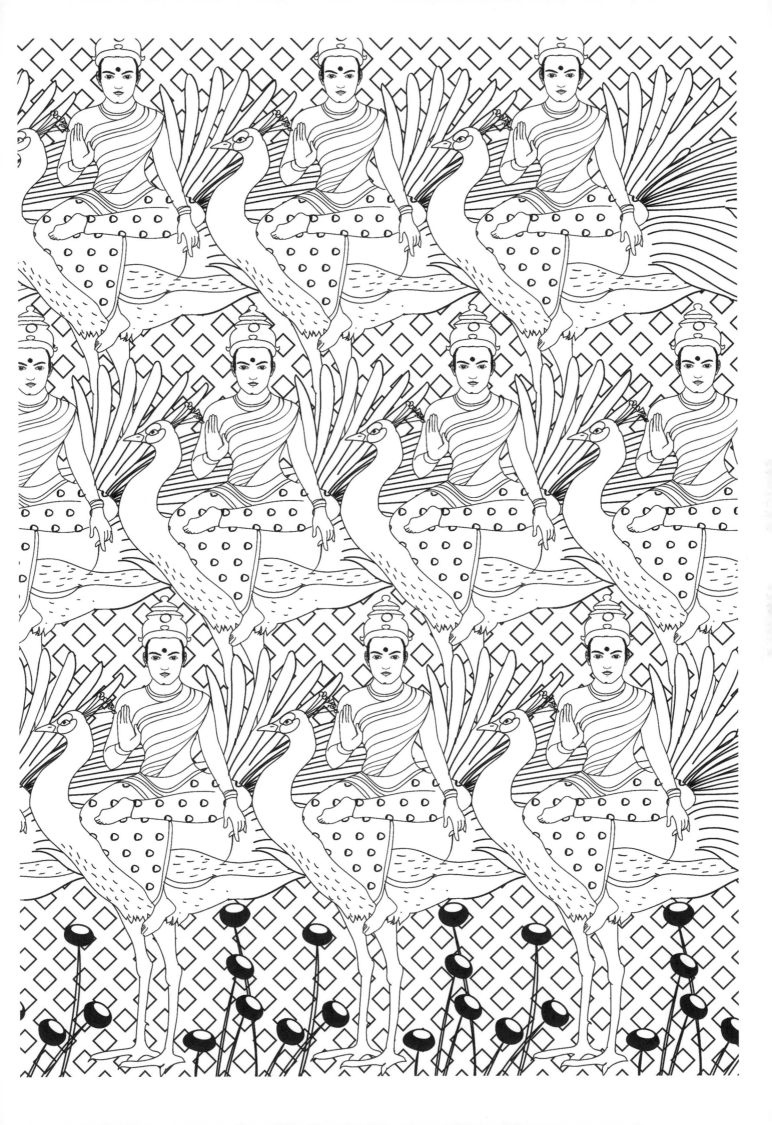

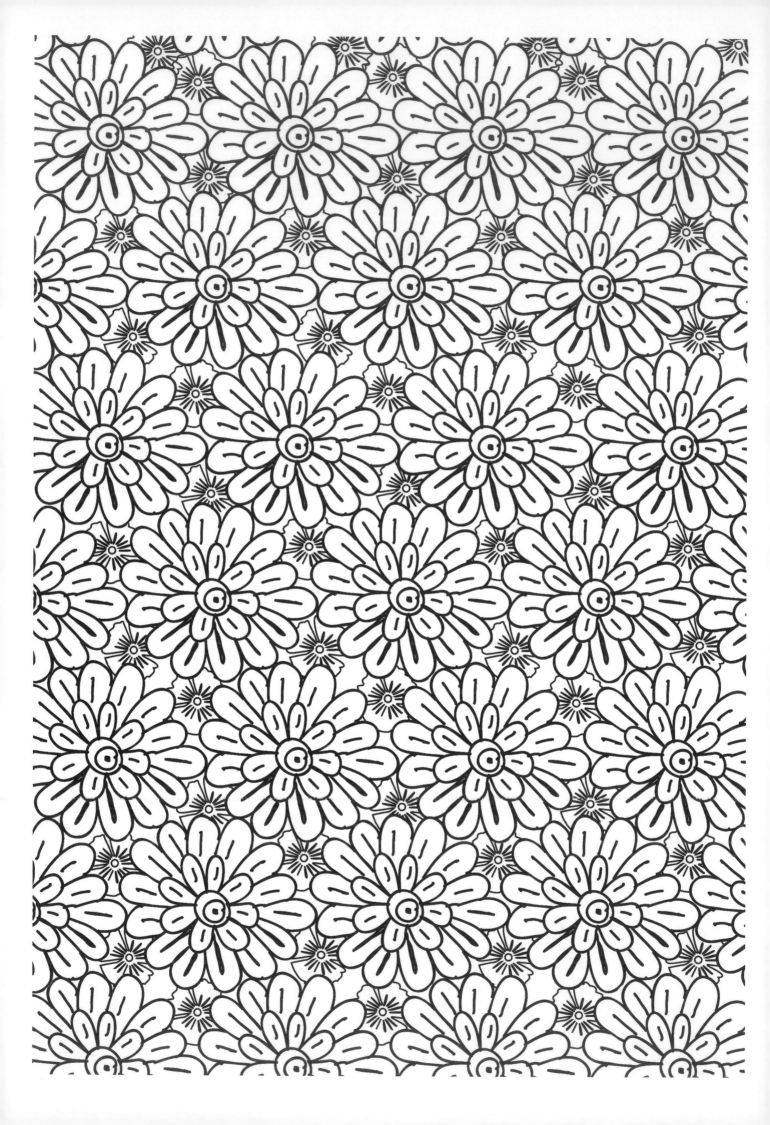

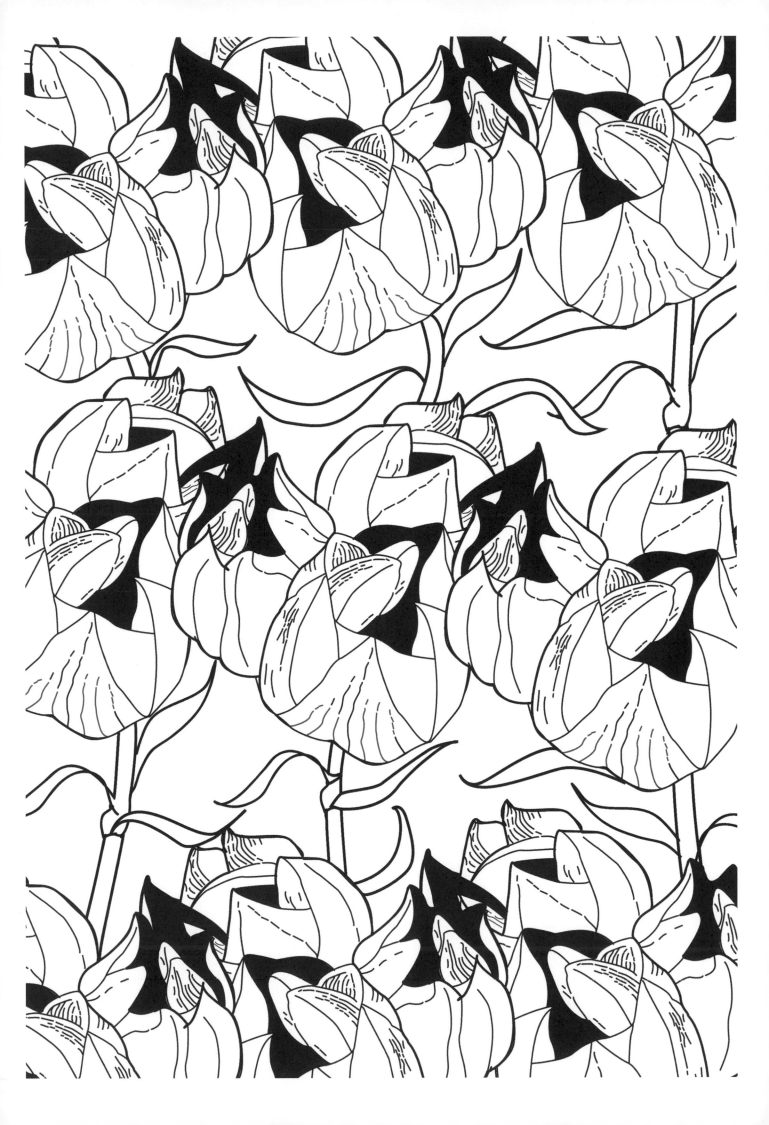

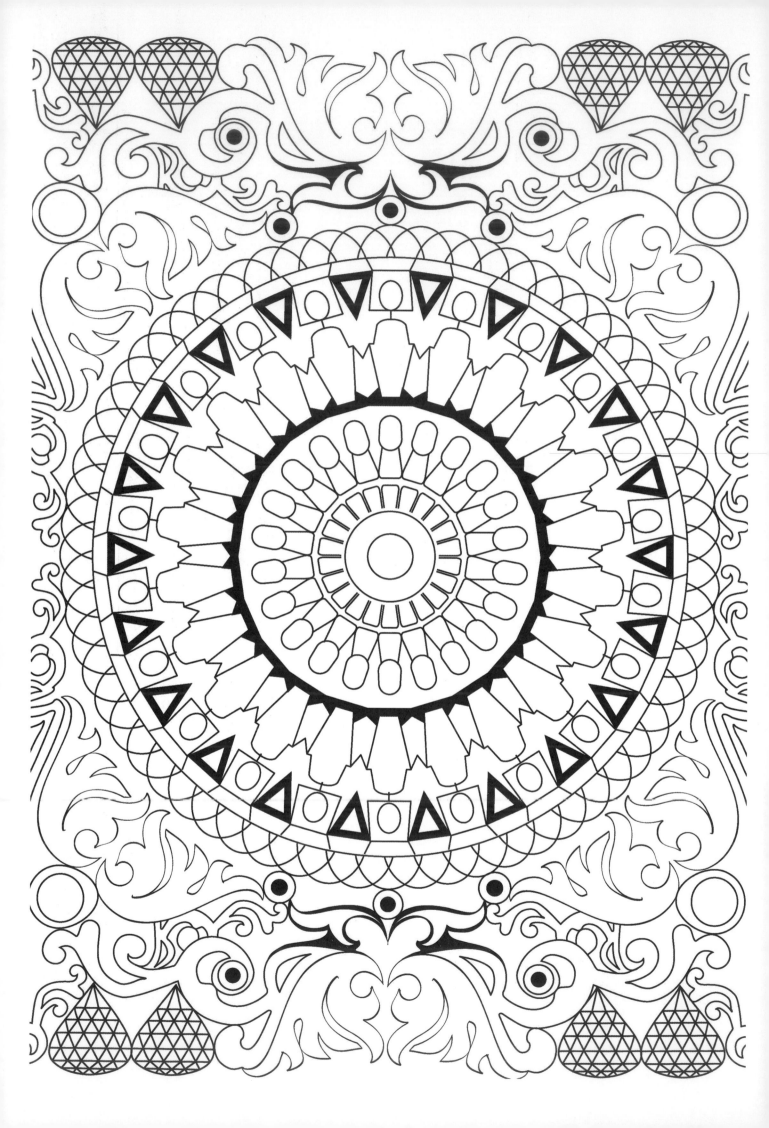

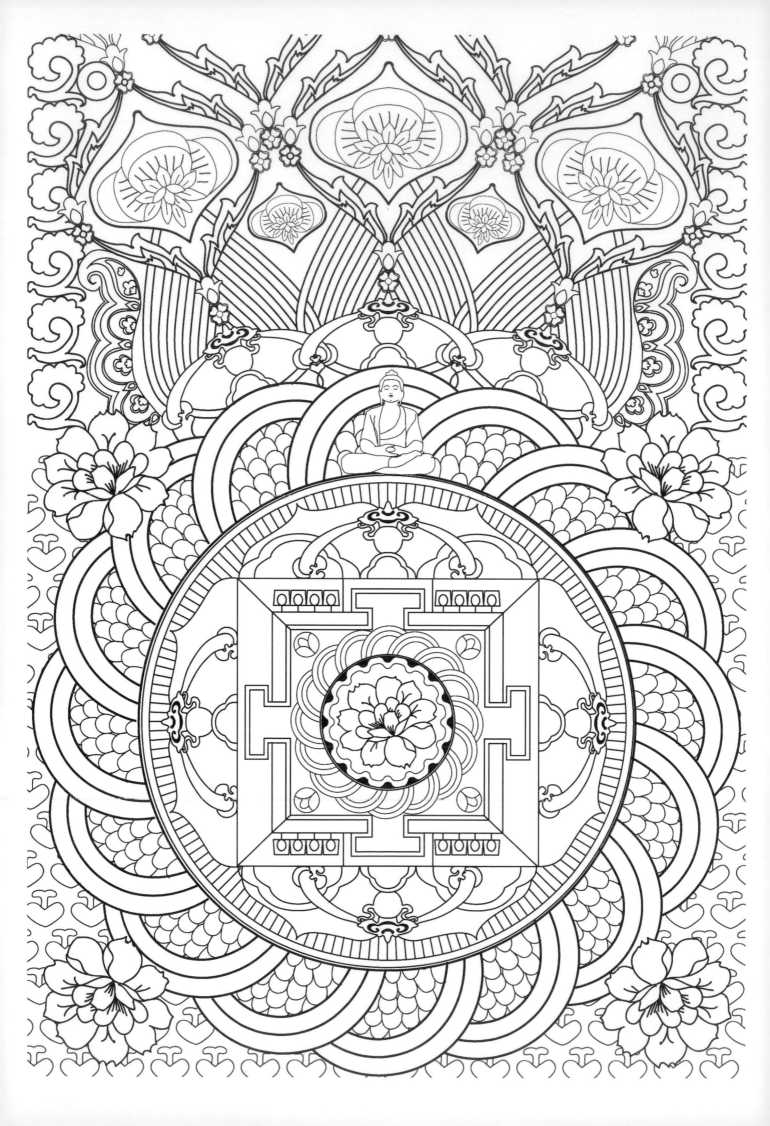

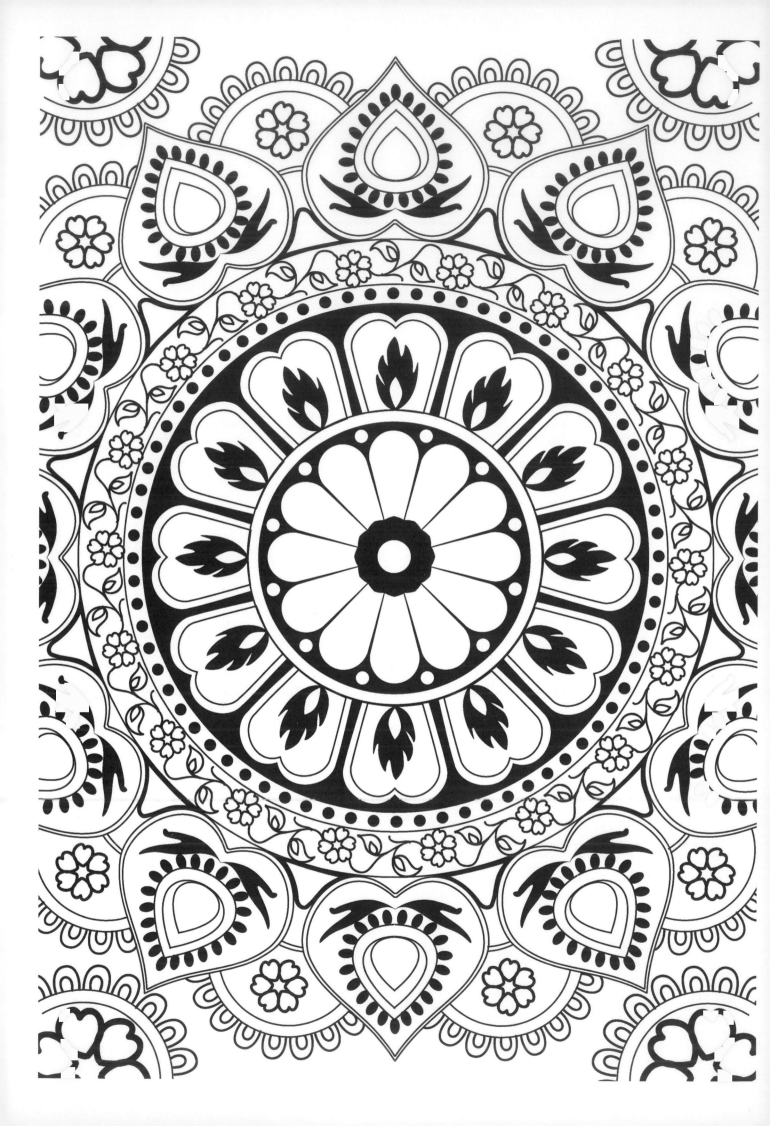

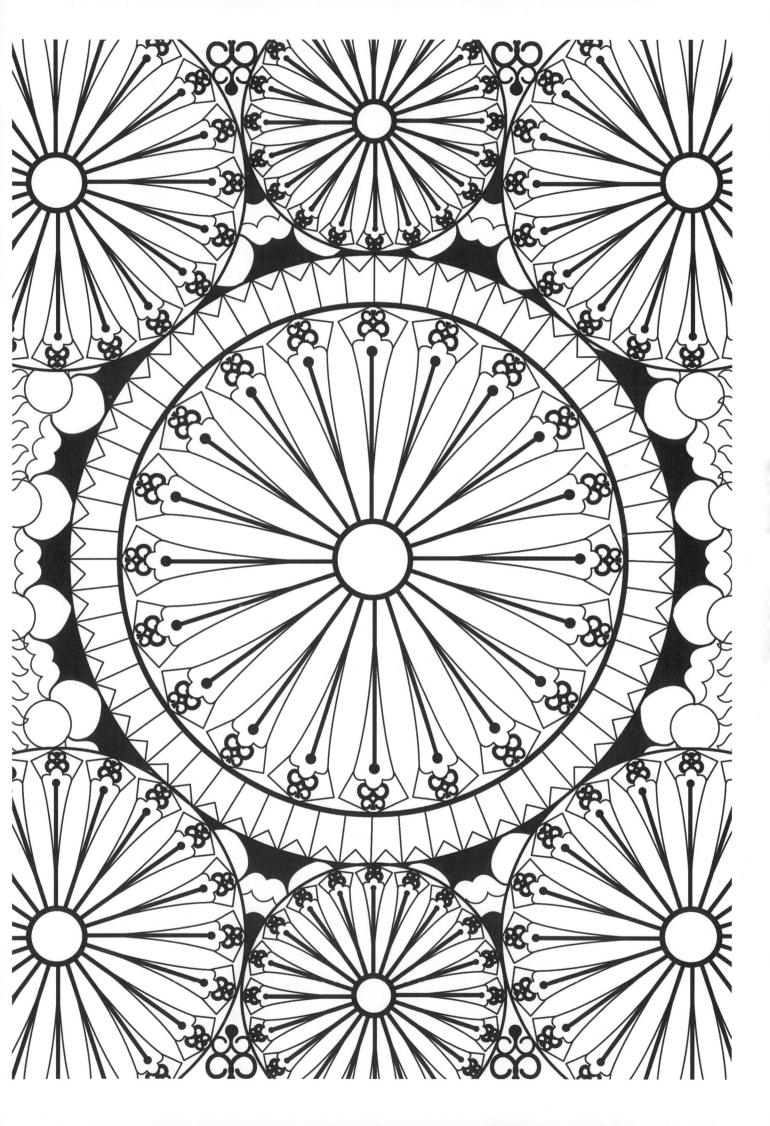

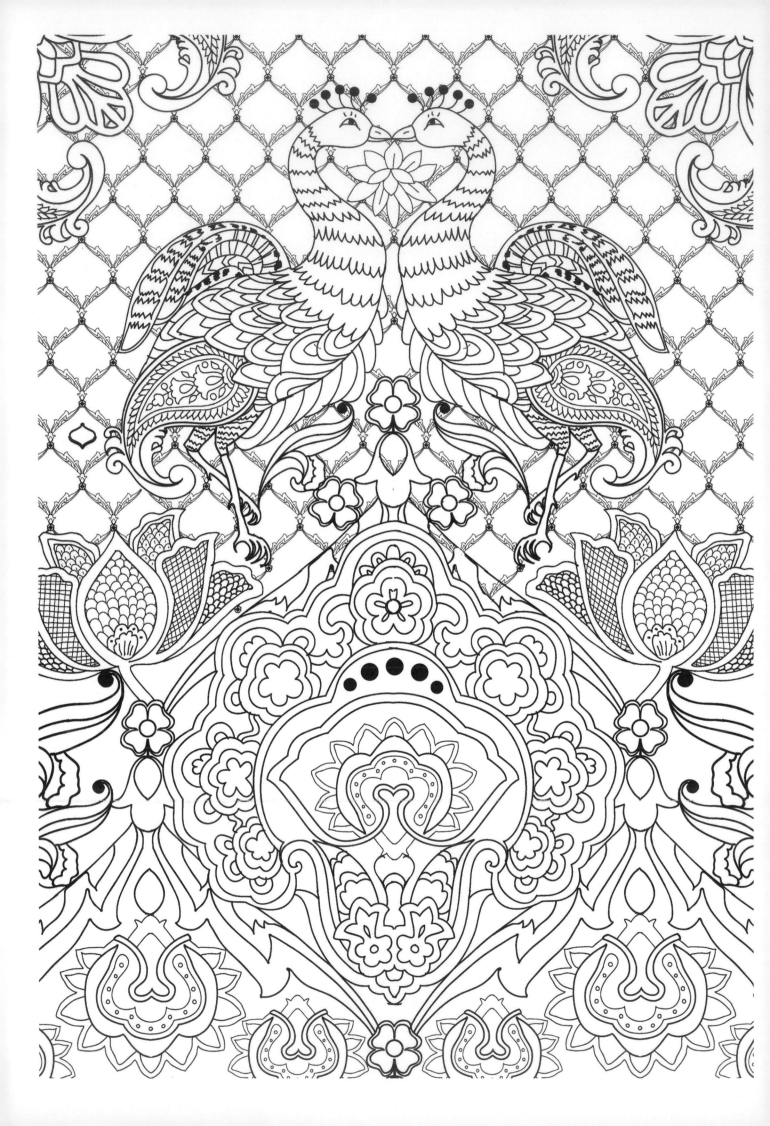

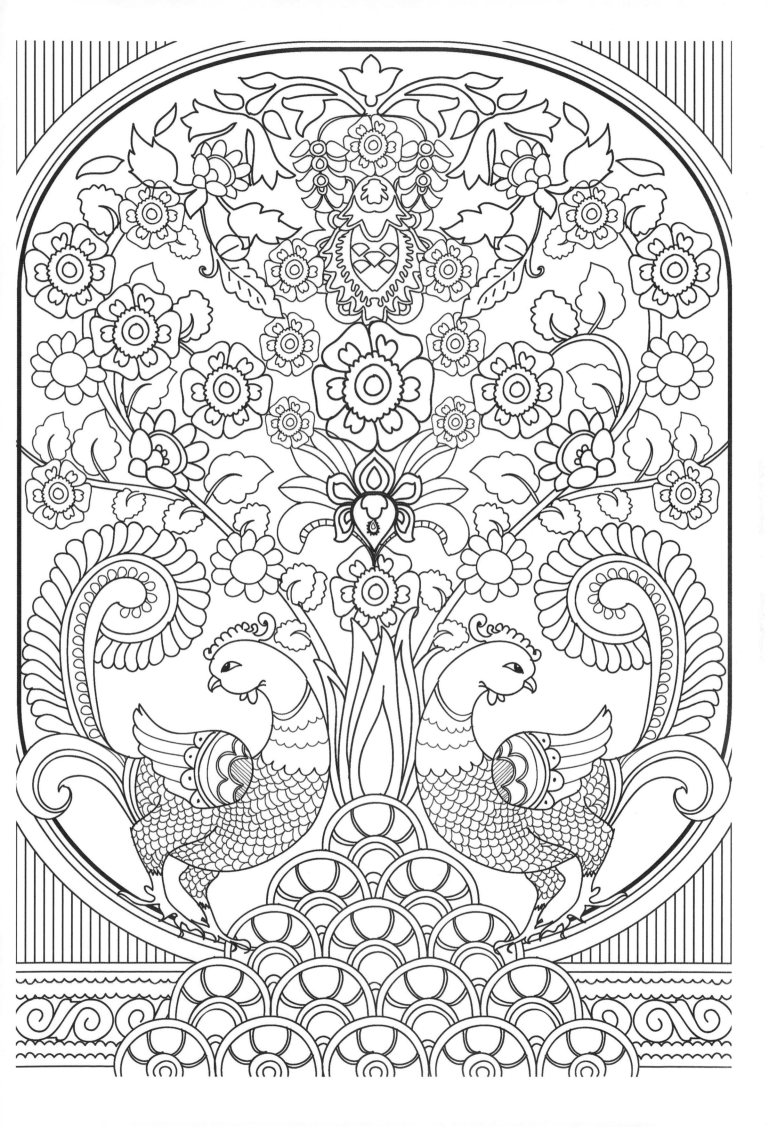

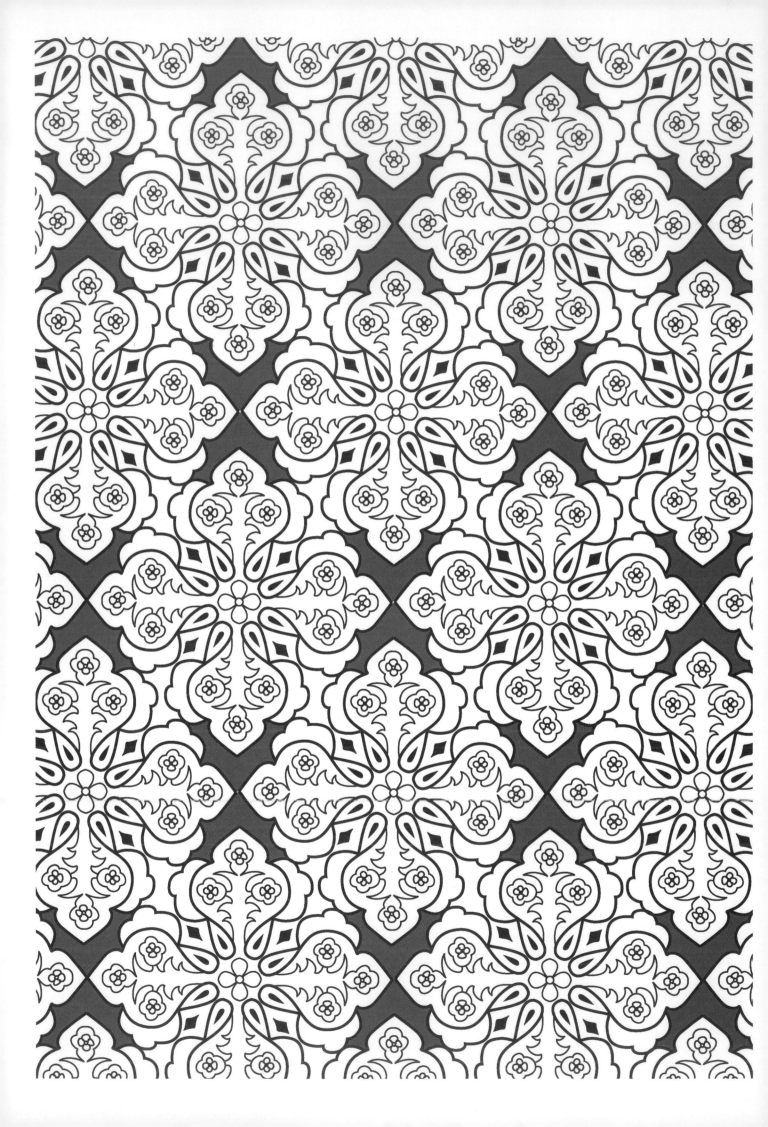

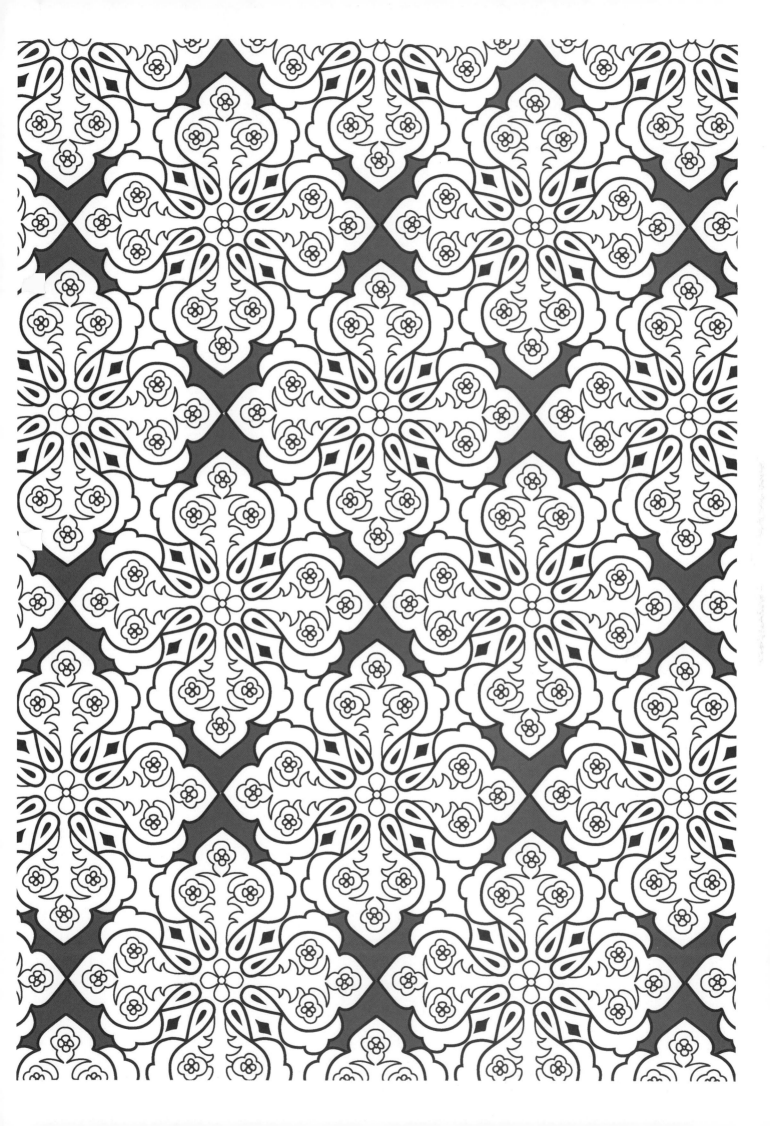

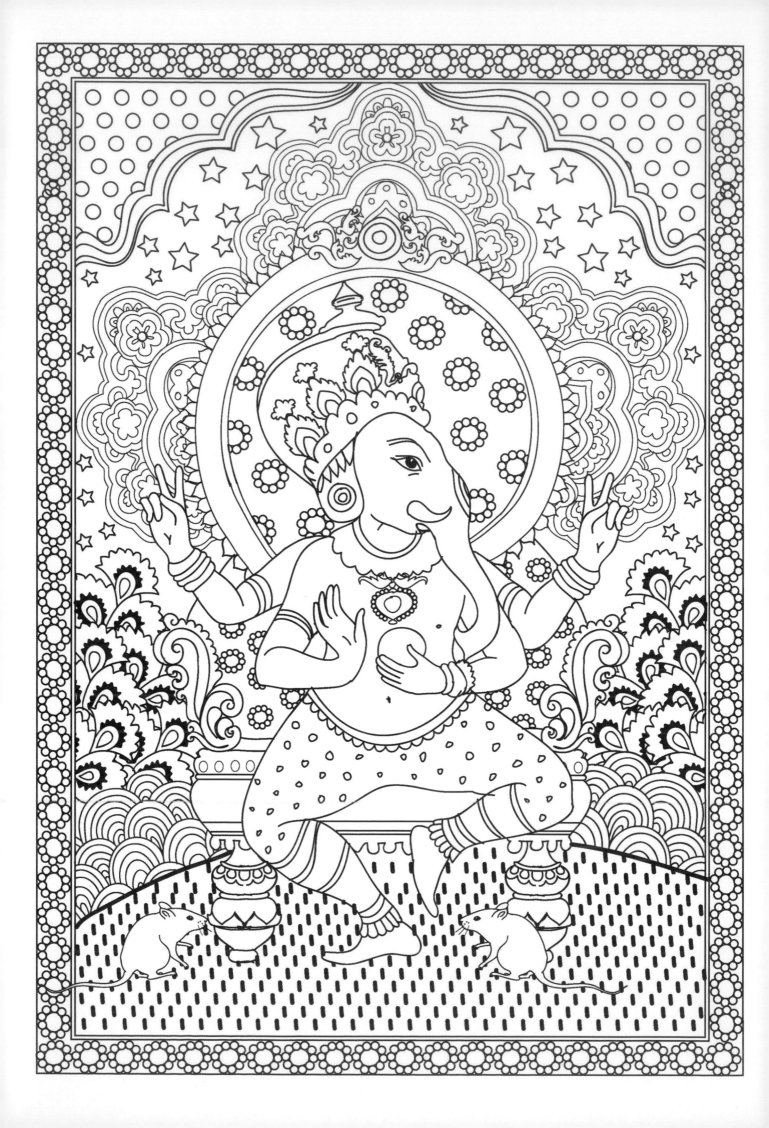

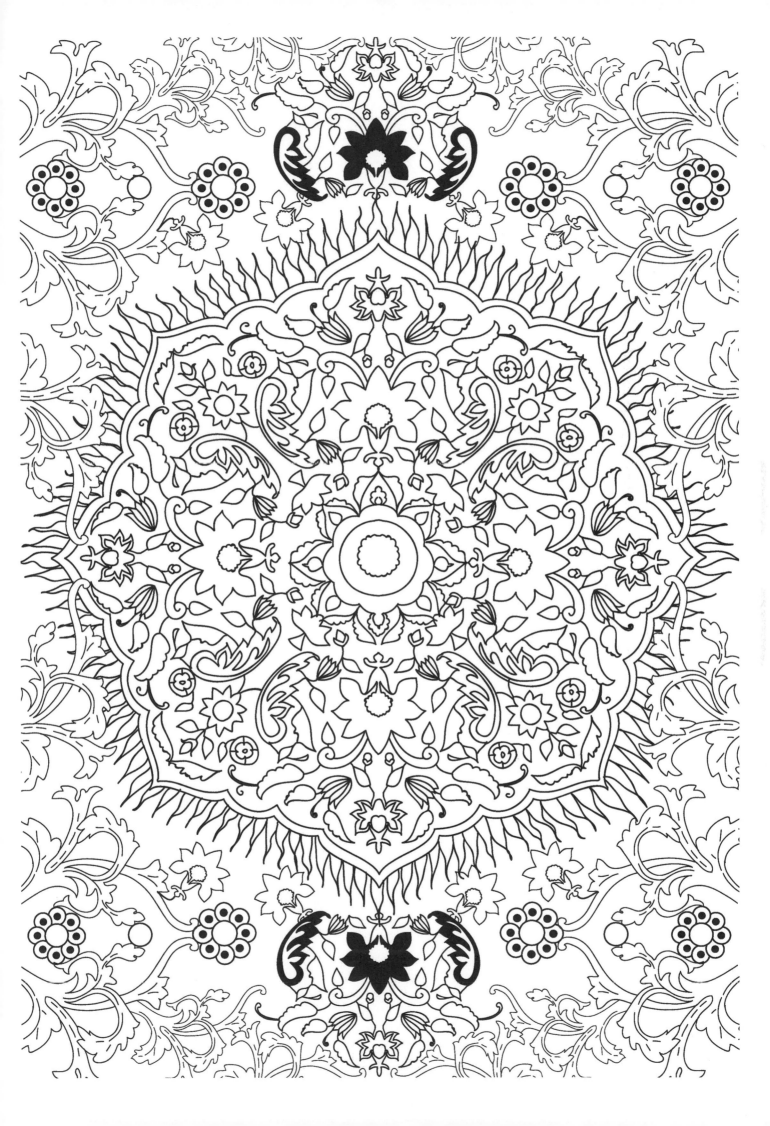

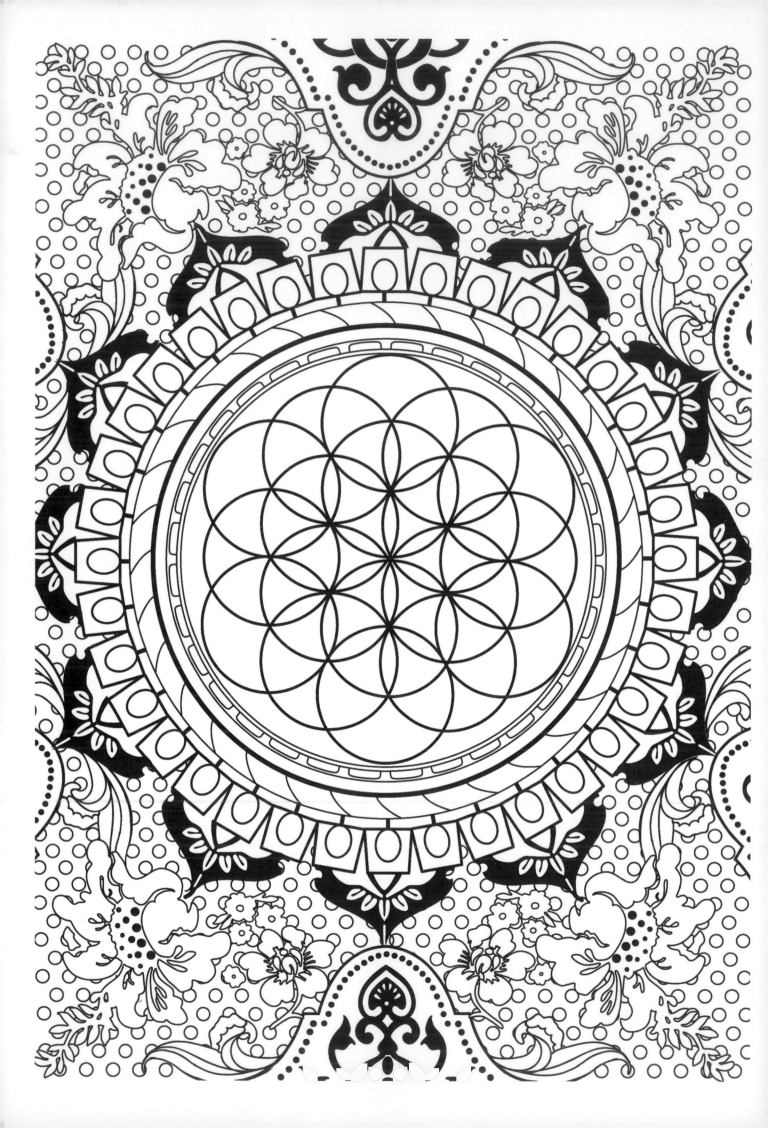

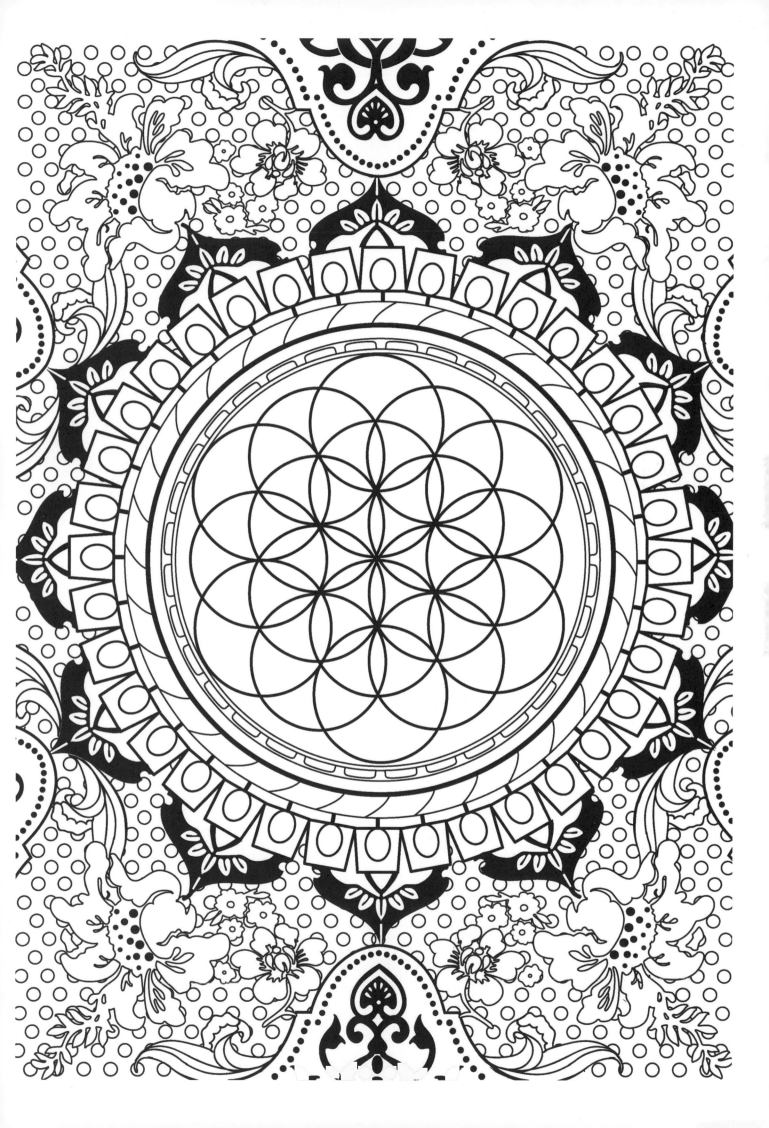